PHANTOMS OF DESIRE

Only for the few.

Art. poetry. music and more. on facebook and more $

© 2025
David Wayne Dunn

my writing has changed since this was published.

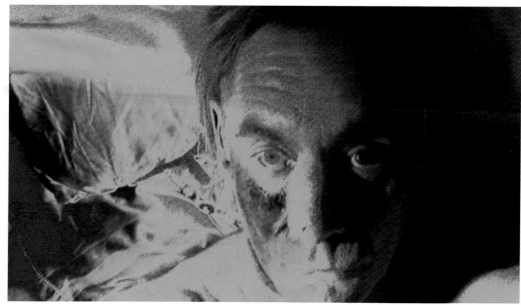

The Artist

View David on YouTube under David Wayne Dunn

PHANTOMS OF DESIRE

Poems and Art

by DAVID WAYNE DUNN

Foreword by Carolyn Mary Kleefeld

The Seventh Quarry &
Cross-Cultural Communications
Wales / New York
2020

Inquiries about "Phantoms of Desire" should be addressed to

Editor-Publisher: **Stanley H. Barkan**
Cross-Cultural Communications
239 Wynsum Avenue
Merrick, New York 11566-4725 USA
(516) 868-5635
(516) 379-1901 fax
cccpoetry@aol.com
www.cross-culturalcommunications.com

Editor-Publisher: **Peter Thabit Jones**
The Seventh Quarry Press
8 Cherry Crescent
Parc Penderri
Penllerhaer, Swansea SA4 9FG Wales
info@peterthabitjones.com
www.peterthabitjones.com

David Wayne Dunn's contact information:
davidwaynedunn@earthlink.net
Visit David on Facebook
View David on YouTube under David Wayne Dunn

Inquires about David's artwork should be addressed to
Atoms Mirror Atoms, Inc.
PO Box 221693
Carmel, California 93922

ISBN 978-0-89304-688-0
Library of Congress Control Number: 2019944565

Book and cover design by Li Yao

Other publications by David Wayne Dunn:
Kissing Darkness: Love Poems and Art,
Co-authored with Carolyn Mary Kleefled
RiverWood Books, Ashland, Oregon 2003

Printed in Canada

Contents

I Immolations

II Unprocessed Threads

III Wrath And Love

IV The Sleep Of Mirrors

V Last Straws

Mary

*It was almost dawn after a stormy night, though the wind
and the rain really hadn't lasted long. Only a trace of rain
actually fell and the wind so very swift and powerful
had now departed.*

*Mary awoke from sleep and drifted to the door. Her robe
fell open so that her breasts and her stomach were exposed
and she could feel the fresh new air of dawn upon her flesh,
and she felt it so.*

*"Right here," she whispered aloud, touching her soft breast.
Mary then prepared an apple that she sliced very slowly
and tenderly. She placed the small pieces just right, peeling
the layers in a kind of trance, or actually prayer. When this
was finished, she returned to the door to see that the dawn
was truly blossoming. The rose of the sky was unfolding.
To say much more would be painful, almost murderous.
Quiet yet tumultuous, living and changing feelings moved
through the mind of Mary.*

*Outside, when rain fell again later in the day, tears fell down
her face and blossomed poems at her feet. And it was there,
upon the ground, upon the abused earth that Mary learned
something. She was grateful.*

*But when night appeared, the wind screamed and the world
became like an animal, fierce and aggressive, primal, like
a fire rising up from the land. Oh, deep fear was the animal.
But Mary was learning something else. She had courage you
couldn't see and faith like all the stars.*

*"Does trust blossom this beginning?" wondered Mary.
"Isn't that where we always are, at the beginning?"*

desire is the essence of a man

Baruch Spinoza

for benjamin de casseres and leonard cohen

–between the nameless and the named

for carolyn,
angel princess of showering compassion.
—a generosity of love and beauty that mirrors All,
and inspires so many.

for patricia,
whose patience and love dwarfs the sky.
endlessly vision-filled.
a lighter spirit i shall never know.

Introduction

David Wayne Dunn is a veritable engine of creation, a prolific poet, painter, and multi-media artist whose work reflects the immensity of his vision. He is also an avant-garde photographer, musician, and composer, integrating his technological skills, all of which are self-taught. A contemporary, yet seminal soul, David infuses his work with a quality we seem to have lost in today's automated society.

David is a chameleon; the changes in the styles of his visual work, both paintings and drawings, are incessant and original. His paintings could easily be compared to Jackson Pollack in the freedom of his creations, although David, of course, has his own unique stream of consciousness. Also, with David I see a kind of Rorschach quality in the sheer honesty that pours directly from him. In other ways, he has the range and originality of a Picasso.

In David's poetry and writing, the reader may sometimes notice a seeming inability to take a detached view of life to overcome his emotional or passionate responses to the world around him. Yet the lush, emotive tapestry he weaves cannot be defined by reason. At other times, David clearly shows his ability to detach and see beyond the mere appearance of things. The primal depth of the wilderness of his unconscious is not to be restrained by the reins of a lesser force. At times, intonations of darkness stream through David's work, which belong as an essential ingredient of the artist's deeper alchemical process.

His profound abstractions—drawings and paintings as well as poems and prose— reveal David to be an extremely brave and diversified talent, a master of how the brain-mind works, and capable of observing and comprehending life from an unconditioned viewpoint.

His earliest observations of life were formed growing up in the once-fertile agricultural valley of Fresno, California, where David had the benefits of wandering through the untrammeled wilds, swimming in the canals, and picking fruit from the orchards. School was not what inspired him; it was his explorations in the natural world and its people. In addition to a lack of financial security, the circumstances of his birth engendered a kind of emotional poverty in terms of

his lack of parenting (his father died young and his mother Elaine had to support three young boys on her own), so often no one was able to be there for this exquisitely sensitive and adventuresome young boy. He nevertheless sensed how to sniff out the richness in that valley, both in his outdoor explorations and in the town and its hotels.

Early in life, he made friends with an older man, a kind of mentor, Ray, who introduced him to Eastern spirituality and philosophies. At one time in his twenties, David considered becoming a monk, but his Adonis-like face and insistent artistic drive somehow navigated him away from that reclusiveness.

Of Greek (on his mother's side) and Irish descent, David combines a most rare and unique sensitivity with a toughness and uncanny ability to deal with an often violent world, carrying roses to the homes for the elderly, loving babies and children with a passion and extravagant kindness. The fact that a consciousness such as David's could be cultivated in this deafened and fearful world is a miracle unto itself. He is a hero for having sustained himself and developed so richly from his challenging childhood and amid the unconsciousness and insensitivity of our times.

David acknowledges the divine spark often hidden in man and has a deeply humane attitude toward the downtrodden and the outcast. By nature he is "of the people," a vital vein of their pulse, and this direct blood connection infuses both his writing and visual art with a sapience that brims over with passion and fertility. Sometimes he sings and strums his guitar and tritar near the wharf in Monterey, California and at times on the streets of Santa Cruz, California communing with passersby and other street musicians, creating an insightful camaraderie between them, one that is curiously richer than the usual, generic interactions.

The acute sensibility of David's genius is effortlessly outraged by what he observes on the streets, in the cafés, and everywhere, meaning the lack of personal connections between people, except here and there. To see the masses glued to their little cell phone space, and their automated existences, is an undeniable curse of these chaotic times. So, as a minstrel-jester on our contemporary stage, David utters his poetic and lyrical wisdoms in a sometimes raw and blatant style in an effort to awaken the dazed robots of the world.

Yes, David Wayne Dunn is a man of lyrics from hat to toe, reminding one of the late Leonard Cohen with his brilliant abstractions and Zen style of being. He is a highly sensitized Stradivarius violin which resonates with a lyrical tonality all his own. David has been able to reprogram his mind and habits with remarkable skill. In fact, he is probably the only person I can think of who has taken that journey of "reinventing" himself and actually accomplished it, many times.

Yes, he is a most extraordinary flame of creation, a pioneer who takes his art to the furthest edges of possibility, and a sublime inspiration to all those who crave original, passionate, and bold expression.

Almost forty years ago, Patricia Holt and I started a publishing company called The Horse and Bird Press, and in 1980 David sent us a manuscript of his poems for consideration. We were both transported by his writing. Although we were not able to publish his work at the time, an enduring friendship ensued. So it feels like destiny that we each now, in some way, have had a role to play in this publication. My deep gratitude to Patricia and our beloved friends and publishers, Stanley H. Barkan and Peter Thabit Jones who made this book possible, this opus of transcendence. Finally others will have a chance to experience what we did long ago—David's most extraordinary work.

Carolyn Mary Kleefeld
Visual artist, poet, and author of over twenty books, including:
The Divine Kiss, Psyche of Mirrors, Vagabond Dawns, Soul Seeds, The Alchemy of Possibility, and *Climates of the Mind*

Paintings

Front Cover:
Photo of the Author

Back Cover:
After Ferlinghetti *36 x 47" Mixed Media on Canvas*

Part One: Immolations

Rain and Fire

Immolations

What mask is this the poet is wearing?
And look how deftly he changes it according
to his desire.
Who is he speaking to?
Do you ever read the strained words
and wonder at all?
It is himself he sings to? Is it you?
Or is it some other fiction—
woman, goddess, child?
Who is speaking these words
intense and imponderably tender
all at once?
Does he really dance to this strange music?
Is pain his warrior or has he twisted humor
around his ironic soul?

What mask is this just now
the poet is wearing?
Do you ever read the strained words
and wonder at all?
And with those flames emerging from
the eye-holes, can you recognize yourself?

Embryo

Was I just born?
I have a wet blanket.
Are we speaking?
Oh, about what?
I'm roaming to listen
but I'm spent.

Was I just born?
Are we old?
Are we almost gone?

Look how pride dies
by the roadside.

Was I just born?
I have a wet blanket.
Are we speaking?
Am I able to listen?
Are we old
or are we young?
Are we almost gone?

Look how pride dies
by the roadside.

Look how pride dies
by the roadside.

If Not Now

A lusting heart is never quiet.
When will we walk to the edge of love,
the precipice of death?
Can peace enter now like a leaf on a stem?
Look how fear falls when the tree is naked,
look how love calls when the stem has surrendered.
Unquiet, the waves of this world's seas are rushing
to the shore.

When will we walk to the edge of love,
the precipice of death?

A Shore Not Claimed

She was a little bit of heaven tonight.
We forgot for a moment the other world
while our bodies drifted with whispers
like silver bodies of water listing gently
to a shore not claimed.

But the embers of my imagination
burned a rainbow away
and I was thrown to the ground
in agony.

The ragged blade drawn now,
the noble door of ecstasy, closed.

And the brief night screamed out:
"the emptiness is endless."
While the darkness for everyone
moved on to
its renewal called dawn.

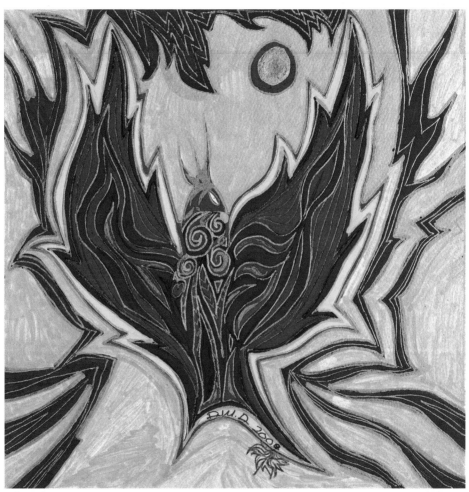

Phoenix

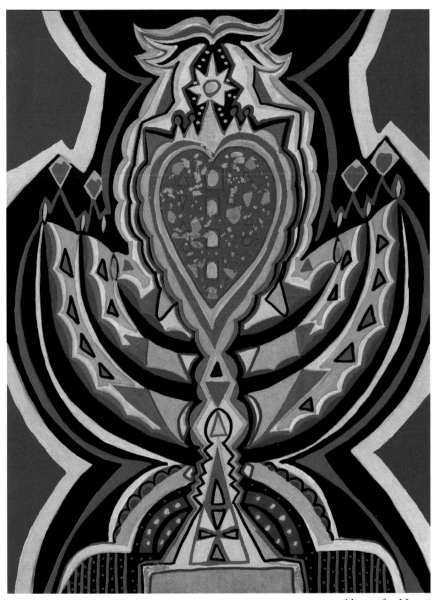

Altar of a Heart

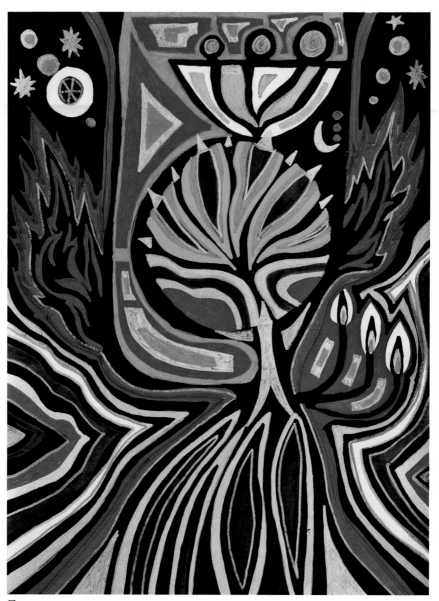

Zone

The Spanish Actress

"I live in poverty.
We ended up here like a blown leaf.
The storms of earthly existence did not
bring me many things, but peace is now one of them.
I was a pregnant woman without a husband.
Before he left he beat me.
But I had my baby and love is all it knew from me.
I gave birth with innocence in a bed
adorned by angels.
Though birth be violent, gentleness is all
my baby knew from me.
Before he learned to cheat and lie
he was a little boy by my side.
Before desire ruined his actions
he was like a blade of grass over which
God was hovering and whispering,
'grow, grow.'
Before fear became the mirror
of worldly ambition,
he was like a soft shadow of a flower
in a garden grown with love."

What Happened To You, Lover?

I'm like that leaf in the morning light
when the tree is just beginning to bud.

I'm like that dried leaf on the concrete
by the cracks and it's the middle of a
winter.

I'm like that lady at the store but I'm
not in a hurry.

Oh southward gazing damsels you
cause much distress and you
have no idea.

What happened to your grace?
Without grace you open doors.
Without grace you don't bother
to be there when it closes.

You walk on flowers and you never
can hear a beggar laughing.

You ignore the world around you.
You feel no heart and you have no soul.

What happened to you, lover?

Fragment of a Theory

Does the eternal sleep
within your flesh?
(At least that's the
theory anyway)

And birds do sing in the trees
and I ring bells praying for
tranquillity or something else
beyond your memory.

And certainly it's not possible
to live without love.
Or is it?

What is this form I cling to?
Not I, not I.

Walking in Dreams

It was a night unlike any other night except this one
was just like last night.
Rain fell over the trees until dawn.
Then the rain ceased and the sky turned amber
while a mist ascended, rose-like, over the awakening
world. But sleep overcame me and I entered the land
of nod. Once there, I dreamt of the most fantastic things.
In one dream there was a man who had no eyes, all his
sockets were full of beliefs and he was poisoned with
the disease of speech.
In another dream there was a woman who had no heart,
but her eyes were like beautiful raindrops.
In the last dream there was a man with topaz ears.
He had a silver child with him whose feet were like stars.
He said, "I speak about love in poem after poem,
do you recognize yourself?"

Night Eagle

Quietness is the sound of you.
Quietness is the thought of you.

The lapping little waves and the white
birds on the rocks in the gray air.

The little lapping sounds of the water
and the sea creatures of some kind
barking out there while prehistoric birds
fly by in the sky.

And the tinkling of the cables.
And the closing of the coffin.

Quietness is the sound of you.

The lapping little waves and multi-
colored stones all silent accepting
every large human intrusion with
grace and slaughter.

The flapping wings of irony laughing
from the night eagle
of another dream.

Quietness is the sound of you.

Door

Dark angel child.
That's my new story of you.
And i shall not stay away,
not stay away.

Dark little shadow of flame.
Aren't you still
a sweet little flower?

Was that just another game?

Wild as the night was deep
under a ragged tree with lipstick
and red paint all over me.

We couldn't see the stars
because you were so bright.

We sang through the sorrow
and we sang through the night.
We sang to the brave
and we sang to the grave.

The young and the old
opened our hearts.

We sang like blind men
as a deaf parade.

Like night eagles now we roam.

A mind with wings and fire
for every bridge to burn.

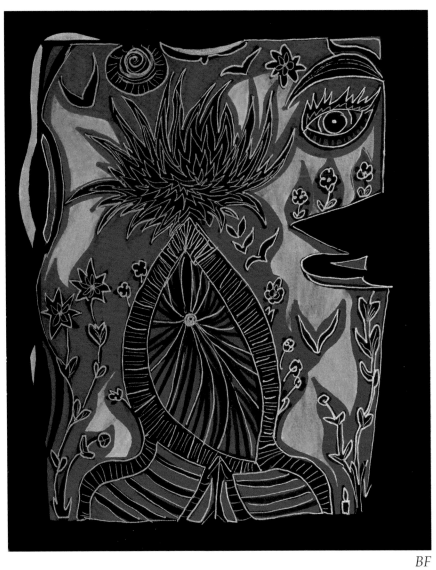

BF

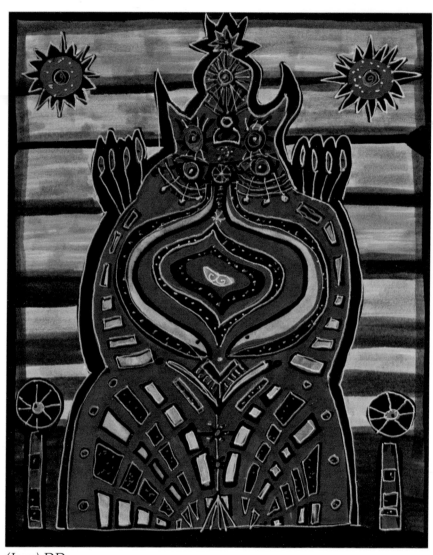

(Icon) DD

A Songless Song

Near the sinless sea over the shifting sand
I lost my hand and found my soul shipwrecked
among millions;
pirated by thieves, beggars, criminals,
and maidens dressed to kill while I was
dressed in rags and my heart was dripping
like a transient masterpiece hung in a muesum
of love and hate, anger and joy, and the walls
were sun-blinded, not a shadow anywhere
to harbor dwindling secrets, while being
stoned and bargained for at a market selling souls
without innocence, like a child discovering their
erotic inclinations for the first time, while the wind
blew coldly like a songless song.

The Unremembered

The harshest lessons empty me.
Is all lost like they say it is?
Is there really no hope, like they
say? And nothing is the body.
Is it all lost like they say it is?
And even my little lies beneath
the flashing lights, are they gone
too?
What season is this anyway?
Is a mind ever unconditioned?
Your body to me was a field
of flowers but your heart a shield
of iron locking me out.
How can I lead myself closer
now to the unremembered?

You Won't See Me

Can a lusting body still be quiet?

What will be left to fall when the tree is naked
but the tree itself?

You won't see me rushing to the horizonless shore
anymore.

You won't see me rushing to the horizonless shore
anymore.

The Train

I took the train of the unknown
to a mysterious destination.
The route was dark and light,
curved and straight.
When the train stopped
I didn't know who or what or where
I was.
The conductor of the train
was indistinguishable too.
He said as I was about to exit,
"I don't think you gave me
your ticket, sir."
I said, "Aren't you mistaken?
I distinctly remember
handing you my life
as I boarded the train."

Rivers of the Heart

Rivers of the heart
Bittersweet memories
Liquid and some not lovely
Over private stones
Lovely and red
Lovely and blue
Lovely and green
'Neath a silver sky
'Neath tree branches
And butterflies
Like a million mirrors
Like sparkling minerals
Like tarnished bells
Still ringing
Like dreams and things
Barely of this world
Rivers of the heart
Like honey flowing
Like wounded birds flying
In a dark and stormy sky

Pride

Wasn't I proud
to be savage and murderous
against those creatures
of the dead that I am . . .
Shitting upon innocence,
not calling upon the angels
for guidance and disrespecting
every leaf, every flower.
How dare I rush by like that
as if of no consequence.

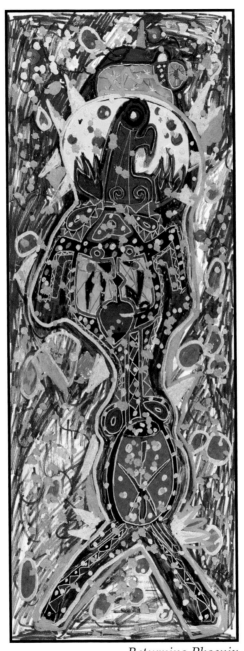

Returning Phoenix

Truth Tellers

The delicious and disgusting merge
like sun and sky.
Babies burn down the road and we eat
our deaf fried eyes.
Is one of us alive?
Is another part of me, you?

The crooked lines of the squinting heart
are revealed in hot blinding time-wasting
distractions held in the palm of my hand.

We are liars no doubt about it. We are truth-
tellers and we are tired.

Then something brief happens.
A day.
A night.
A life.
And all the flowers too,
and large water lily leaves
wave like elephant ears,
goodbye.

Love

In the waking courtyard another empty ray of light,
another paradox in plain sight.

Still the day became sweet; there was no one to meet.

In the waking courtyard, another empty ray of light.

We sat there with conflicting memories of your eyes
and what is it that last dawned on us.

In the waking courtyard another empty ray of light.

Part Two: Unprocessed Threads

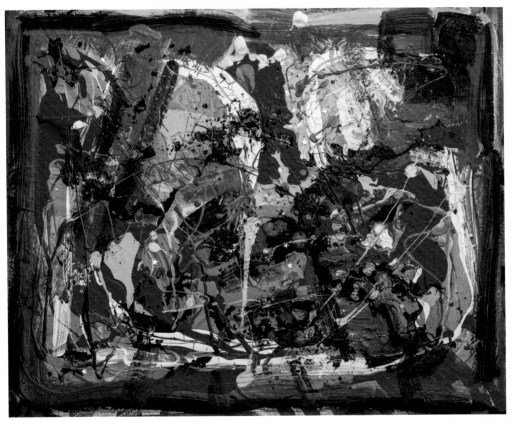

Jazz Bird

Shiva

Laughter and tears
like little heart-held mirrors . . .
tears all bottled up
are we bound to explode?

Faithful hearts
however untrue;
everyman desires her
jewels even when she's
not wearing any.

A breath of life
in the cage of men's souls;
goddess to artists
and children
whose beauty depends
on her; might as well try
to rejoice about it.

Another mystery
with tiny ears, coyly
violent.
Secrets soft as
dove feathers.

The reason for singing.
And the reason for things
that require no reason.

Storied Fragments

She was an old woman taking her newly bought
toaster home on the bus.

If you think this is funny you have another
thing coming.

The grave of the night awaits no one.
The grave of the night awaits all.

The grave of the night used to cry with me,
now it just sings.

I was a ship on a dry ocean, your presence
filled it with beauty.

I can't believe I took so much.
I can't believe what I believe.

In the realm of dark fog you were light.
In the harshest of winters you were spring,
sky, bird, flower and tree.

These tiny lying eyes . . .

Twilight by the river but there's no river here.

Brown leaves on red bricks, or something like that.

Isn't everything always 'or something like that?'

I never knew they made such things —
rivers and people who used to dream by them.

Hidden Things

Stay dark, sweet light. I am at ease at this moment.
Stay dark, stay light, stay dark oh sweet light,
we are at ease at this moment.

The sound of the rain is not insane, dear reader,
and I don't much care what happens next.

The orange of the sun gives a lovely glow behind
the flashing and trashing silhouettes of birds and men.

Now watch us stand alone. And the world our throne.
Behind every tree there's something to see.

How long will it be before I forget you and sit beneath
another?

From where this fondness for hidden things?

If you were here I'd sit beside you, but you're not.
Consequently . . . Behind every tree there's
something to see.

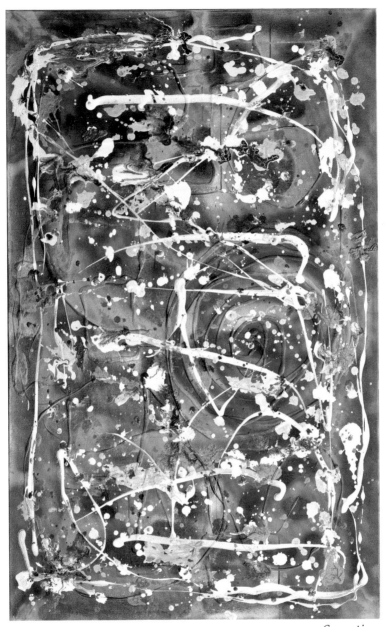

Spacetime

unsaved gifts

large raindrops
small shadows
silver mirrors
closed windows
warm stoves
upside down women
tough sisters
proud boys
humbled brothers
large raindrops
small shadows
shining eyes
stinking mouths
cold digitalism
smelly dogs
abstract humility
i'm sorry
i'm not sorry
large raindrops
small shadows
arched rainbows
dirty tables
wet fish
small eyes
uplifting darkness
tiny fingers
where's the sky
who will laugh
when you die
large raindrops
small shadows
unsaved gifts
music everywhere
are you deaf
large raindrops
small shadows
someone prayed
for your soul

Not a Gun

The other guy had fried chicken and she had a flower
in her hair but she sat way over there and nobody cared,
nobody was here, the mental
space was all occupied. That's what happens when dreams die.

Do you remember the longing and the hunger?
Do you remember the loneliness of your culture?
Do you like the drunken unconsciousness?

Now is it like a mirror uncovered of shame, naked of blame?
No one comes and no one goes, or so it seems. Makes
you wanna scream. Or sing.

Do you remember the servers bending over?
Do you remember the glad solitude of public
bathrooms? Do you remember the shit running down
your leg?

Do you remember those blinking ATM machines
and the look in our eyes pushing those buttons
for leisure's prize?

All I wanted was a body, not a gun.

venom

lower the children gently
you bastards of war and misery
i'll get your throat from behind
the lines are drawn on paper
but everything changes
if you don't believe me now
you will someday

curiosities of the body's explorations
death and rebirth
rebirth and death
samsaras they say
if i were enlightened
i'd just let you go
just let you go

flowers in a tower
and roses on the snake
that has my name
let's compare venoms
and moral virtures
you bastards of war and misery

No

Your past is more than I can take.

I should've shut my senses down to keep
my mind wide awake.

I stored you in my crystal heart but your mother
broke it all apart.

My joyous duty was to praise but the body you left
could hardly be raised.

I should've shut my senses down to keep
my mind wide awake. Now you don't know what
to think and your past is more than I can take.

I'm outside the palace door where life is all imagined.
I don't notice anything really that tangent.

See how you've become nothing and I grow and grow?
I've shut my senses down, my mind is wide awake.

You are like an actress in a worldly drama play.
You've decided to take things serious and I just want to play.

You past is more than I can take.

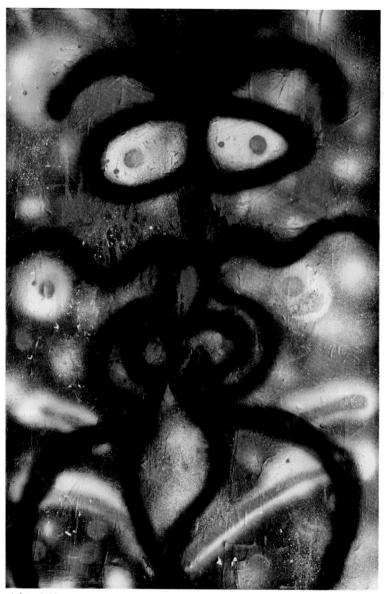

After Miro

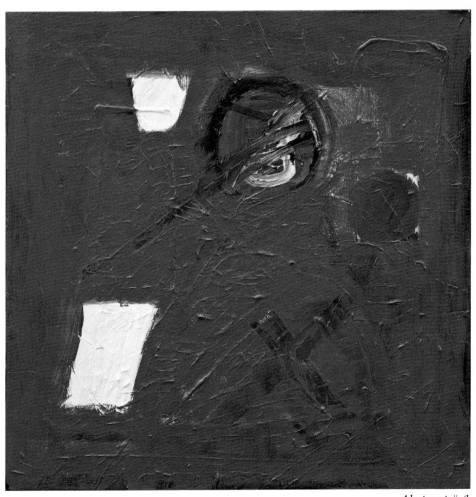

Abstract # 1

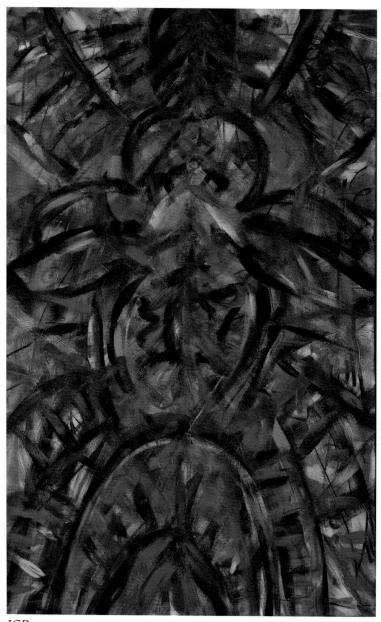

ICP

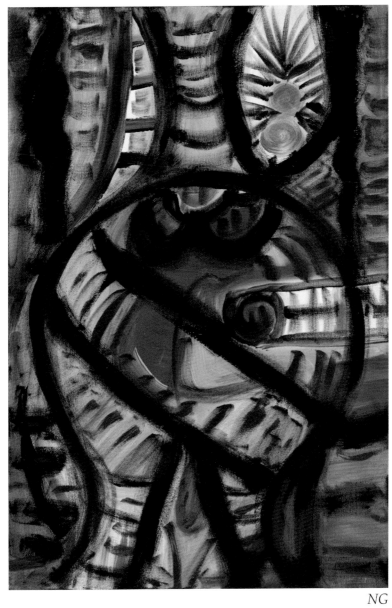

NG

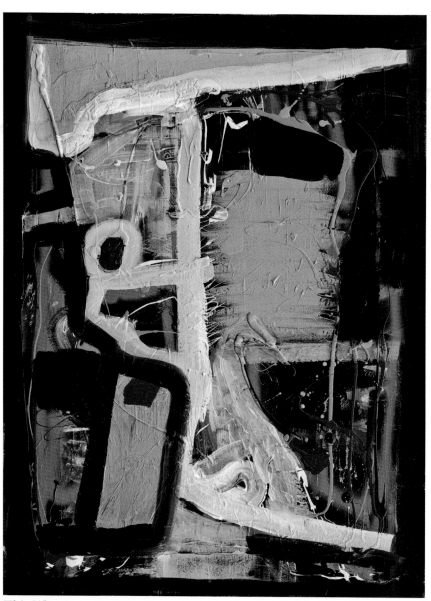

This Way

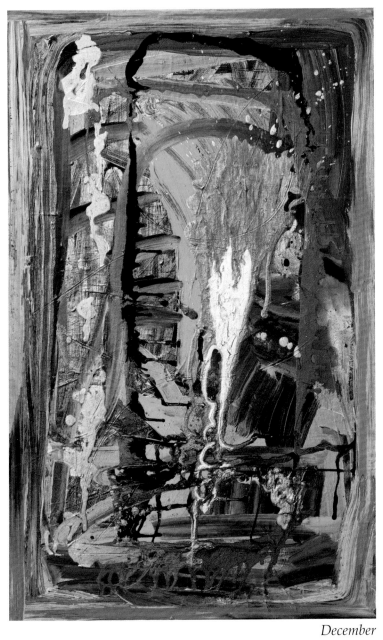

December

social justice (for r. j.)

as if a corpse
i woke up to sticky flies
buzzing around my skull.

woe, have i died?

would you like
to lick clean if anything
is left after the hungry buzzards
have finished their meal?

pardon me, you'd rather
discuss world peace
and social justice
and you're not kidding
me either?

Infidelity

A limitless play
of polished mirrors.
A warm fire
in a cold heart . . .
blood, piss and semen
and the fulfillment of more,
less.
Honor never was a stone.
If you can't lend a hand then get out of the way.
Who wants to go first?

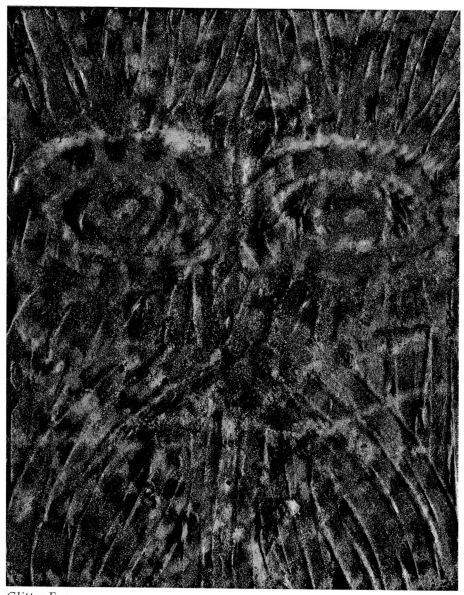

Glitter Eyes

Whory Night

The saintly night became a whore,
the stars grew lips and the moon was a thigh.
The whole universe was a ball; it warmed
everyone and my body was a mouth blowing
bubbles.

The whory night with saintly stars,
secret lips and sensuous thighs.
The whory night, a large-shouldered shawl
of sex and lies, truth and cries.
The whory night, infidel twin of many hearts,
faithless sisters.
The whory night, a giant black bitch
that has never been broken, fucked
by all the stars.
The whory night, slut of an echo;
the eternal mother of betrayed soldiers,
sinners, holy men, and spinsters . . .
loving mother of all thrashing her children
against the blinding walls of day.
The whory night with saintly stars,
secret lips and sensuous thighs.

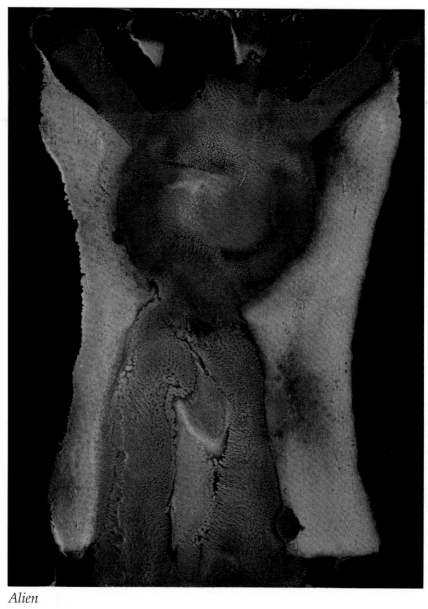

Alien

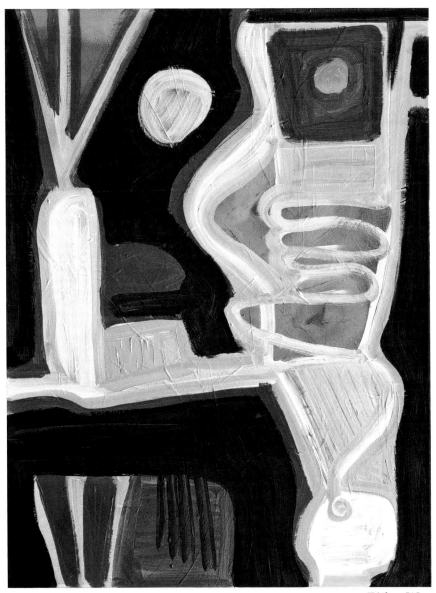

Either Way

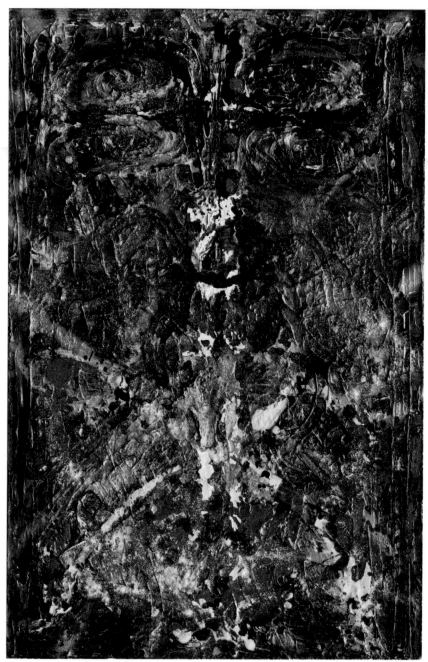

The Dance of Her Face

tomorrow

little stinging mirrors of tears
fingers like petals
beating hearts
like shapely asses
goddesses of love
warriors of hate
broken and repaired
with heavy eyes
closing forever

peace as night
too brief
whispers with shy smiles
a few moments left
to rest
the parade begins again

cowgirls and clowns
dressed to thrill
dressed to kill

thin prayers beside
a wishing well
who will begin again
like always before
you can never tell

Twin

Goodnight true friend—
you are vast and protected
by infinity.
The cloak of stars loves your
wasted arms, they hold no
memory but of love.
We'll be together now.
Goodnight darkness, does your
smile come at dawn?
Wink me to sleep my brother
before the midnight which
always dreams.
Oh colorless sister of the end,
oh black sky-brother of the crowd;
you come and go so quickly
as if you are my twin.

bells

somebody's miracle
delicacy and desire
grow grow little flower
the never-ending lessons
of life and death
are not learned in a day

seen and falsly felt
waving trees and other
things on unmarked paths
from a million blind windows
from a million ringing bells

mother's dream

oh children who skip from the busy group
to gather petals for dreams
oh children who wander joyfully
whose tears are sometimes a wild scream
oh children who sense caressing whispers
of much that is quiet
like plants flowers and trees
oh children just being born
and children poor and forlorn
oh children who wonder and care little
for our sensible answers
what is a star a house a world
oh children whose laughter is like
the early beginning of an erotic sting
oh children of your mother's dream

will the heart strike again

will the heart strike again
anvil soul to metal wringing
gold from corruption
singing to cities and to hillsides
the bells are rung for all
and all are the bell

will the heart strike again
viper in the night winking
blindly and shadows of clouds
drift while leaves on trees stir
towards an autumn fire

will the heart strike again
brave soldiers
upon the grave land
and the winter not waiting
while the stars never grow old

will the heart strike again
some are more sensitive than others
all is a flower's bone in a blue sky
thoughtless
a body of love seeking pleasure

will the heart strike again
while the dawn is coming
and the sea is flowing

will the heart strike again

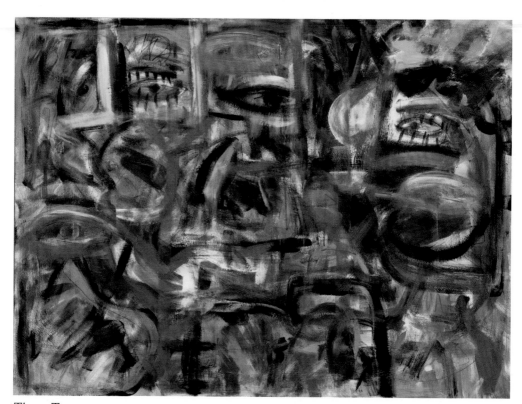

Times Two

Dying Without You

Don't call me dead;
call me dying without you.
Sometimes like delicate piano keys
ringing like bells on a cold moonlit night.

Don't call me dead;
call me dying without you.
My Asian warrior friend never
understood either though we secretly
admired one another between our
watered down theories of life and death.

Don't call me dead.

I'll talk about the cracks in the sidewalk
where I'm standing some other time.

Till then, the only God I ever knew
was in your eyes.

Part Three: Wrath And Love

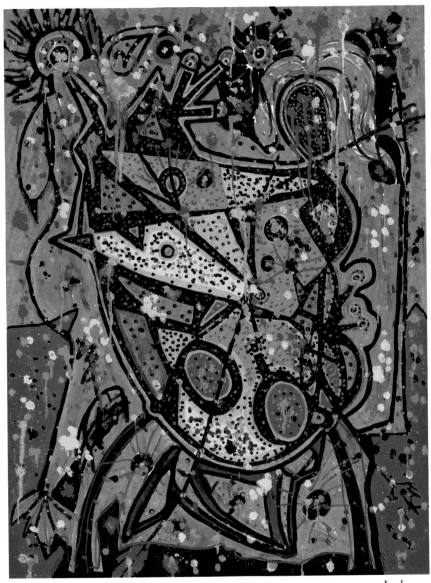

Jealousy

The Alchemy of Grief

White hands.
Black night.
Oh Federico Lorca.

Soft wind.
Hard city.
Oh Federico Lorca.

Not far away,
another blue dawn,
soft flesh.
Oh Federico Lorca.

Oh disassociated sisters
of sorrow never to come,
never to go.
Oh Federico Lorca.

Oh gypsies of the alchemy
of grief, sing your songs
to the hearts of the misbehaved.
Oh Federico Lorca.

Empty eyes lost in singularity,
no longer to multiply.
Oh Federico Lorca.

Small histories growing smaller,
dreams more ridiculous.
Oh Federico Lorca.

continued

Sleepy eyes seduced by the
smile of girls and their black lashes.
Oh Federico Lorca.

White hands.
Black night.
Death's beautiful mask.
Oh Federico Lorca.

Ruth Sang the Blues

Ruth sang the blues without saying a word.
All you had to do was take one look at her
to know she was corresponding in
terms no longer joyful.
Perhaps it would be better if she turned
more often to the trees. They too
never say a word but who am I to know
what is better or worse for Ruth or for
my little life of illusion and loss?
But I do think the trees reveal certain
correspondences. Don't you?

Oh how I love to sit beside them
as beside a lover full of secrets.
Now what good is woman, man, tree
or star without a few secrets.

I have secrets unknown to myself.
Probably always have and always will.

That was my contribution to the betterment
of the world. The great unknowing.
And I, unlearning about a million things
for I could learn to learn.

Oh how I love to sit beside them
as beside a lover full of secrets and death.
Don't you?

Dead with Time

I am the great I Am.
You're a flashing dying pan,
a child dead with time.

I am the creator of lies
and the silver in the mirror
of eternity.

I hear birds singing and I see blindly.

Except when looking at you.

Is my heart playing tricks on me?

Material Realms

The moon has no gate
and you slip not from your shoes for me.
With your golden breath are you glad
to suffocate me while your hair waves
gladly in leaving?
Will I love forever your dead Madonna eyes?
I am captive by the hands of a ghost.
I was caught by material illusions.
You're like a child that grew beyond me.
The moon has no gate
and you slip not from your shoes for me.

in the terrible moonlight

she weeps not from the silver window
before the snow-white hills in the terrible moonlight.

it would be like this! she smiles and breathes,
as all things do, for eternity.

oh who am i to disagree with what is chained or what is free.

she weeps not from the silver window
before the snow-white hills in the terrible moonlight,

but smiles and breathes as all things do, for eternity.

Something for the Modern Stage

Something for the modern stage,
I know not what pose it is.
Long have dreams flowed
from the fossilzed tears of poets.
Long have lovers stranded in worldly
chains been drained by the blame
of the pain.
What shame we must disavow
to dry ourselves with the towels
of freedom while we sing like peasants
in crumbling towers.
Flowers that you grow will never know
what secrets we kept while we slept
with our arms entwined.
There is and there is not
time my love,
like the wine we sip
as death nips at our souls.
And so we go unlike we come
naked and singed
with light of virgin glow.
Are we now reborn,
torn from the thighs
of those who cried
with courage before they died?

Silly Dream

Dark night, raindrops from far clouds,
gray windows, red dreams.
Her little fingers dazzled him . . .
each digit was a flower to smell.
Lions stir. The heart can smile.
Color bleeds magnetic blood.
She had lips like Elvis Presley.
He imagined kissing them.
He imagined them smiling.
He imagined them speaking, moving,
laughing, crying, screaming.
Her eye lashes seemed as long
as her hair, and as black.
She kept her head bowed;
her eyes looked so tender that way,
so sensitive.
Could she feel he was stealing
something from her?
She wore a blue coat;
it was like blue fire.
Was she different from the others
who were hard and worldly, or was
that his projection?
Of course. But she seemed more soft,
more innocent and clean, like me.
Ha! Fresh as morning.

continued

Then children ran by, playing.
He was beside her now
and there was nothing outside.
No other thing existed.
He wanted to follow her home
and in his fantasy, he did.
He watched her getting ready
for bed, all contained in her
own beauty, her own flesh,
needless and white.
He watched her brushing
her hair and could feel her
breath sighing and her body
relaxing as she curled up
inside herself, contained
and tender-hearted, hair
covering the pillow.

And if she awoke and spoke
he was sure her voice sounded
like the inside of a jewelry box,
or like velvet bells.

drips the honey

now night
now day
do you come to rest beside me
no
like a wind
barely noticed
in a light garden
fragrant with
a flower's presence
no
a leaf upon flesh
tree trunks around
limbs
no
yours the mystery
of many men
sitting by the well
beneath arches
in the moonlight
yes
where drips the honey
into eyes
into souls
into hearts
no
is separation
only a game
everybody wins
and loses in the end
but not without
you
yes
sitting by the well

The Lips of Memory

Oh crown of life
fallen like death.
A kiss forgotten
on the lips of memory.

What mirage have I married?
The separation has torn
the curtain, lifted a veil.

There is no exit to leave from.

The sun was still golden
when you left.
The backyard flowers
meant something quietly
and no one was rushing.

The prophetic glowing butterflies
drifted by with smiles in their eyes.

I wondered if they were thinking
of you and how wrong that would be.

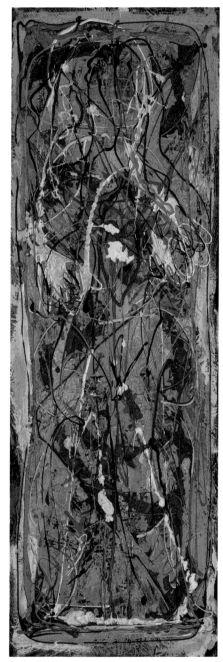

I Was in There

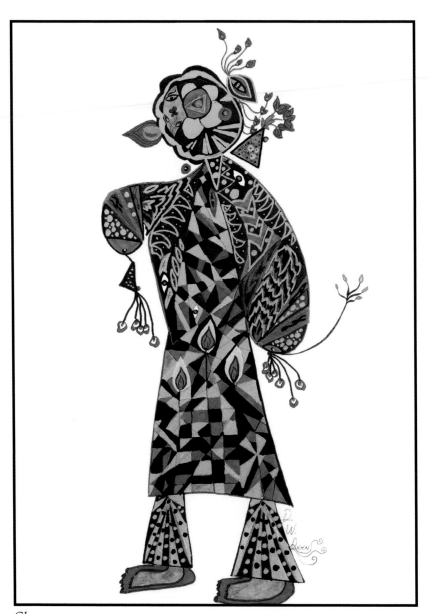

Clown

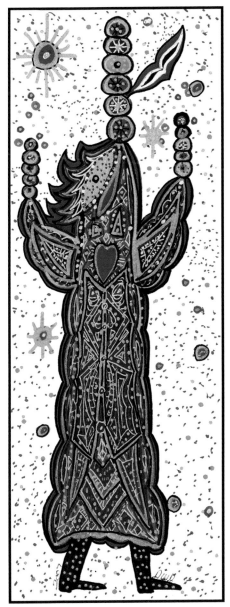

Juggler

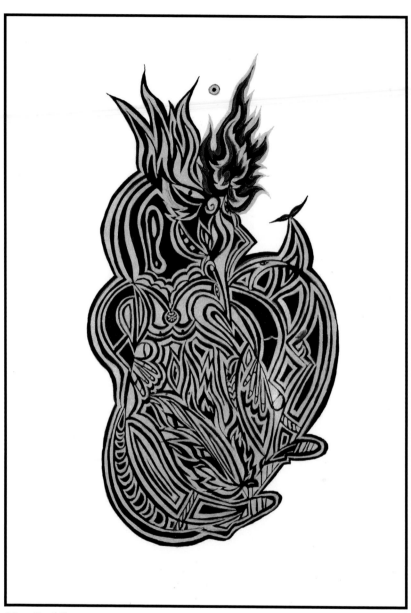

Non Buddha

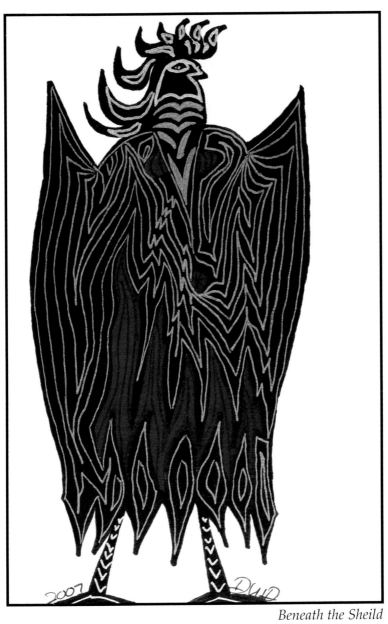

Beneath the Sheild

the illusion

you are the beautiful fountain
i am the water

you are the fertile earth
i am the flower

you are the wave
and i the breath

you are the dream
and i the rest

All the Things

All the things I've longed for,
have they found me?

What a terrible hunger.

Peace, love, light.
The jewels of your eyes.
The diamonds of your cries.

What a terrible hunger.

What haven't I imagined?

All the things you are.

More than my arms ache for you,
more than my body.

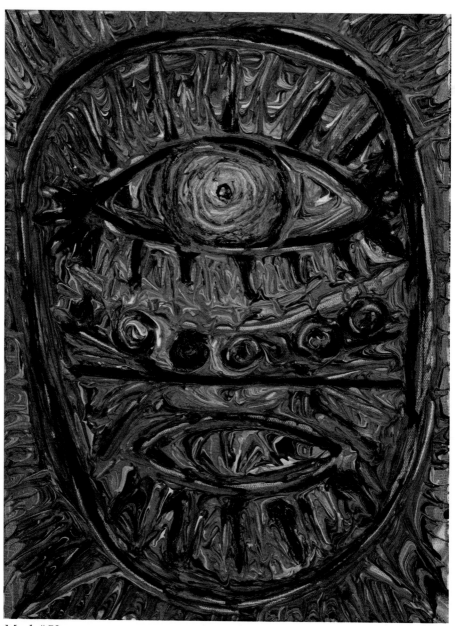

Mask #53

Maya

I danced with illusion again tonight,
her arms so devilish and long,
her eyes like boxes of kittens.
When she smiled the planets danced
and her lashes flashed like stars
while I shivered warm inside and
didn't know if I was overfed or starved.
I promised too much and gave her
my last piece of bread . . .
she ate it quickly and I asked for a hug
more true than yours.
I told her she should be in Hollywood,
I could make her a star;
everyman is not the same, come on.
I don't know if she even heard me
and if she did I don't think she felt it
too deeply or took me too seriously.
But she promised to think about it.
The scar her beauty left on me
was deep enough to last lifetimes
even if I never danced with illusion
again, which probably wasn't about
to happen anytime soon.

Jolene

The breathing came from the night
or from the next room
or from heaven I couldn't be sure . . .

But from the stars of a prayer,
something, what I don't know,
sounded deep, fragile and strong
all at once . . .

How many little breaths in all this
universe; how tender do we sleep,
how strong must we live, how severe
must we die?

Life is a sea waving against a shore
shifting beneath your feet.
The night was quieter than I,
and trees were still.

Some mornings, please feel the gifts
between your breaths and the
birdsongs outside.

The day promises nothing which
is everything to one such as I,
and I believe we must try to live
before we die.

Dark Eyes

What was never there,
her dark eyes.
What was she thinking?
What was always there,
her dark eyes.
What was he thinking?
And rain was dripping
and the clock was ticking.
When he went to sleep
and when he awoke,
was she there?
Was he never without her?
When he awoke and when he slept.
When he walked and when he sat.
When he smiled or cried.
When he said hello to someone
or when he said goodbye.
Was she like a misty river
or a city street,
it does not matter.
Sometimes she wore black,
other times, yellow . . .
Or she would say, "when you
come tomorrow, what color
would you like me to be wearing?"
"Whatever pleases you," he would answer.
"But since you asked, I love red," he said.
Like a thread of a prayer was she woven
into his coat?
Words are useless for such questions.
They were beyond words . . .
pleading words, hungry words,
thirsty words . . . they seldom needed
them. And wonder of wonders, did she
know his wishes long before he gave a hint?

Magnolia

I wrote a few poems
when younger, on blue
and firey nights full of
human hunger.
Maybe I'll write another one
someday about your memory
I can only project my needs upon.

"Always expect the unexpected,"
I heard someone say.
(May your heart discover new wonder)
"New wonder is everywhere," a friend
did say. And what is worth knowing
more than this way?

Oh magnolia of the opened leathered leaf
in the courtyard of the present moment,
how can I love you more?

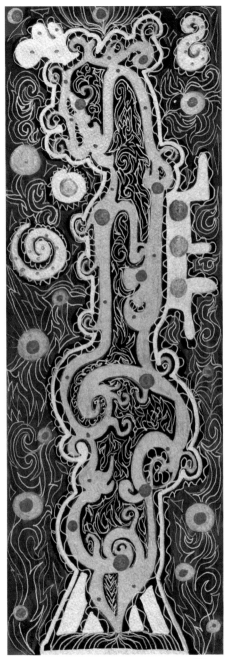

Flute

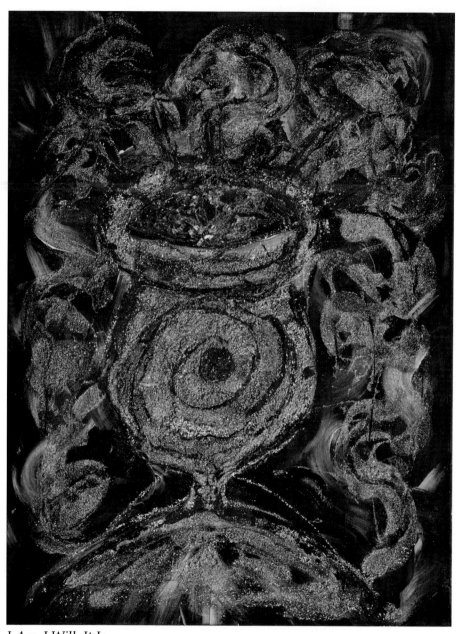

I Am, I Will, It Is

Strange Song

How did it feel
when your gravity was still,
did you think you were fleshless
all along?
And isn't it cold there in your house
full of yesterdays—
the skeltons are beautiful
but they make me very tired.
It's not that I know you
it's just that I love you
but you always said,
(and didn't I agree?)
life can be so multi-leveled.
But I didn't quite understand,
(should I say that I'm sorry?)
when you said what you said
about energy fields
that were not something one
could hold onto.
Then it became your turn
to cry. I didn't know what to say
so I just closed my eyes—
they were suddenly warm.
And we always agreed, didn't we,
that nothing ever really dies except
for our lies.
Now I see by the window she's living
in memory; it only bothers because I've
been there too often.
Oh how did it feel when your gravity
was still and did you know you were
fleshless all along?

no becoming

all my heart
ever gave you was me
but it wasn't who i am

had we been where we're going
would i have gone with you?

am i really here now?

Don't Worry About It

Faded remnants of reveries from the dying tree
of what is incomprehensibility.

Nothing means what it used to, if it even meant
what it did before.

I saw a leaf once turn into a flower.
Now I wonder if I'm going blind to what is wonder.

I was kind once or twice in this world.
Will I be angelic in the next?

I was kind once or twice in this world.

I was blind a whole lot more.

More Beautiful Than Life

Fulfilled steps of beauty,
a stairway of passion not needing
to weep; desire still desires to live.
Nights of black rain and smiling back
doors, but reach around your arms
as the night undresses.
The sea calls but not to you.
Memory is like fire, only ashes remain.
The house keeps burning to the ground.
How I want to let you go;
So many gestures unmade.
Brush your human hair,
paint your human lips.
Does fear fall when prayer
fills the hall?
The sea calls but not to you.
But Everything speaks of you.
Black dog, white dog, red dog.
Sea birds that never know the shore
exist for you, especially when you're
tired, weak and worn . . .
More beautiful than the life we knew;
A diamond inside a rose,
a girl inside a boy . . .
Man, woman, child; all the same
to me.
Like the silver in a mirror
or the reason for quietness.
Oh how I wished sometimes to
become you and maybe will
someday;
like light on the water
or something darker between
your thighs, and not hidden away,
the love between your limbs,
and feel no pain because of it
and know this moment of ways
which answers everything you dream.

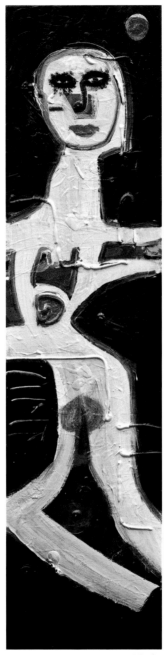

Twin

Part Four: The Sleep Of Mirrors

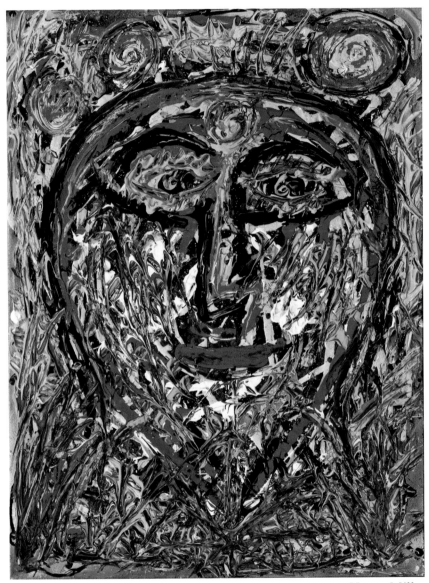

Henry Miller

Forest of Symbols

They walked in a forest of symbols.
Leaves were like waves, tree limbs
became arms, the trunks of trees were
female and male bodies.
Some were quite contorted and odd-shaped,
even errie looking in certain twilights,
like the countenances of people in
strange light.
Little metaphoric birds were in the bushes,
little thoughts of God.
Then night and darkness, when many lights
are revealed; night-lovers emerged
and stars appeared, cool and far away,
or ageless, near and warm, in a forest of symbols.
Then dawn, a maiden's white ankles,
if maidens be white, walking over the
horizon with bloody thighs.
Old bones, like memories, line the path.
The sky was a mirror for whatever, and love
in all its complexity (or is it simplicity?)
was growing and overflowing everywhere.

Something

The radiant glitter
of themselves.

Like flowers making suns.
To think of anything else
seems a waste of time,
probably.
The lush dark hair
like a velvet river at night
through a thought of a forest
that must rest now.

Like flowers making suns.
It must be that way sometimes.
So I was trying to remember nothing
and heard the sounds of heartbeats
behind glass watching her climb the
ladder then remembered the one at home.
It must be that way sometimes,
and joy was given and received
in the most defenseless way.

For Patricia

A sky-dream for my grounded mind,
a song for the star's hearts.
Your earth overflows with mystery
and abundance while knowingness
rings from your soul.

The life I've never owned
is graced by your arua.

Even a star's glow
pales in comparison,
though a star is what you are.

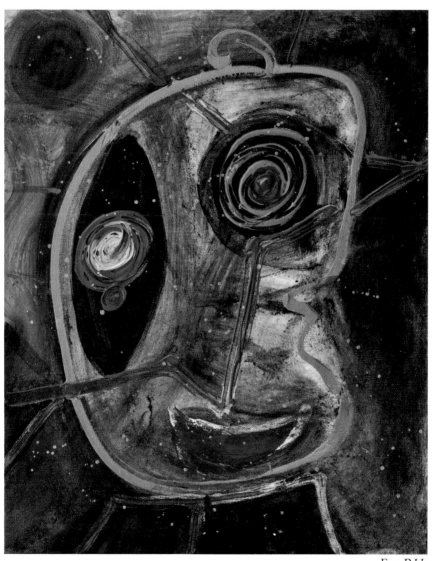

For P.H.

Something, Again

Did I hear the first bird at dawn today?
Maybe it wasn't today and maybe it
wasn't the first bird, though I thought
it something worthwhile, like a breeze
in a tree.

Success, like a tinkly dart thrown into
the ears or softly closing little dark eyes.

Like something again and again
where words are almost sins.

night raven

night raven
vulture child
self-lit flame
dancer of heartbeats
upon a rotten floor
night raven
vulture child
sister of luxury
mother of fame
love dream of danger
mistress of memory
memory of sorrows
night raven
vulture child
boy girl
woman man
mateless lover
cousin of farewell
daughter of fantasy
night raven
vulture child
veil lifter
life stripper
soul seeker
dancer of heartbeats
upon a rotten floor

death in the window

death in the window
death in the street
death in everyone
you meet

death in the death
death in your hair
death on the phone
death walking
death talking
even death singing
death with a dog
over dinner by the stars

death while driving
death without a cry
death digitized

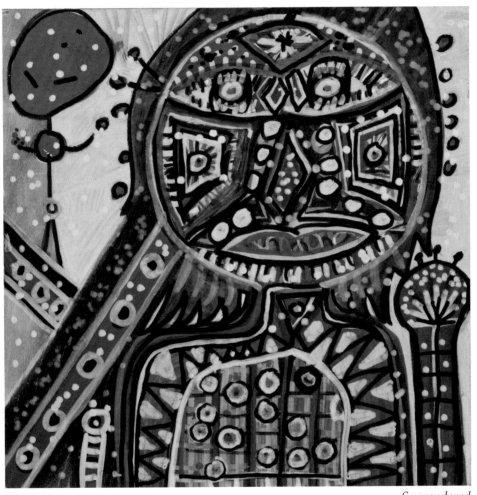

Surrendered

Revolution's Prize

Like a bird that wants a sky.
Like an orphan wants love.
Or a dog a bone.
We wanted you so bad
and the need so great
it was like murder.

Rotten to the core now.
Like a maggot with a bell.

In the blackest of hearts
I saw the deepest light.

In that strangest of deaths,
in the heart of a world,
on blood stained roads,
frantic.

And the ruby rug pulled out
from under us and the raging
hungry seagulls in the air
and on the ground.

I hope it's nothing
like I thought it was for you.
But I hear that it is.

We see, we feel, we think.
We laugh, we cry.
But we live? We die?
We feel pity and remorse?

continued

Oh traceless reaches of the sky!

Am I learning to hate?
Am I at the gate?
Am I in front of the gate,
or behind it?

Oh traceless reaches of the sky!

First Song

Frost upon the earth
and storms up in the sky,
some flowers just a-blooming
others about to die.
One man smiling,
proud as he can be,
another man toiling,
drifting lost at sea.
The colors of your soul are turning,
the desires of your heart keep burning.

Frost upon the earth
and storms up in the sky,
some flowers just a-blooming
others about to die.
There's evil in the world
I've been told and believe it true.
There are arms that feel like angels
when you're down or feeling blue.
The colors of your soul are turning,
the desires of your heart keep burning.
I took a walk alone, the road was steep
and long, I found you quite near the end
singing a sweet song.
You gave me your reflection
in the waves and in my eyes,
I heard some birds singing,
I heard some birds cry.

Frost upon the earth
and storms up in the sky,
some flowers just a-blooming
others about to die.

L.C.

Leonard Cohen died.
My mother died but she lives in us.
My father exploded long ago.
My brother said, 'fuck it', then took his
treatments to the bitter end. He wasn't
that old either.
I guess we're all going to die. Imagine that.
The body has its little joys and can only last
so long. So long.
Leonard Cohen died.
Is everything gone? Yeah, everything is gone.

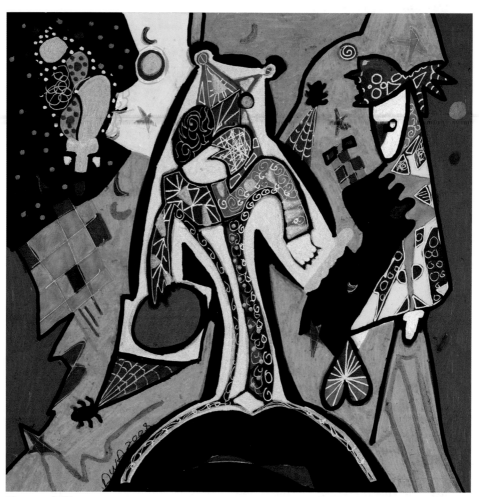

Personal Circus

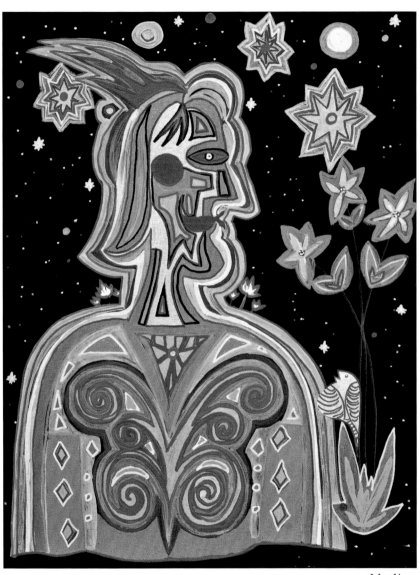

Idealism

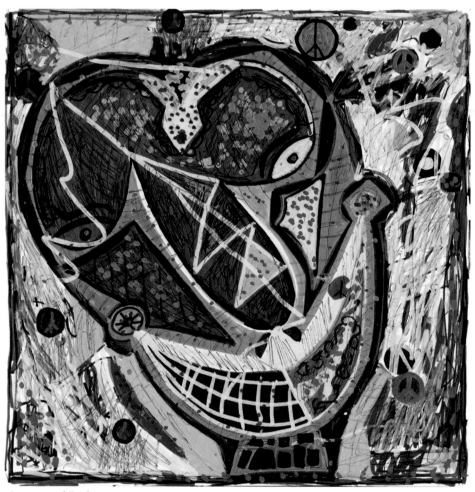

Anger and Jealousy

He Used to Go Where . . .

He used to go where they place their eyes
and think of his hand there all entwined
without a problematic past in the middle
of the night when all the ornaments are dim.
They say the sun won't die for a long while
and maybe I read too many melancholy
german poets when I was a teenager.
Back then it was a kind of water to another
crying animal.

They say the sun won't die for a long while.
He said your eyes were like flutes singing
under the trees. He said the shadows of
birds were something to see.
I ring the bell and there you are.
I ring the bell again and there you go away,
with the moon in your hair and cakes
in your hands.
When the smile of your sweet heart reaches
the desert, seek my face, remember my grace.
The future only gets blessed by forgetting, and
by remembering.
Are we never triumphant at the end?

new day

mixing the unintended
the exploding past
a revolution of now—
music from the back
music from the front
borrowed or stolen
no longer begged for
it's june 27th 2017
there's a road
going backward there's a road
going nowhere

it's been foggy for
six days will i
be home soon?
this world i hear about
what do i miss?
your smile or your guile?

now it's like a sentence
a form unpardoned
clear as a mirror
but it reflects nothing

will i be home by fall?
you're never there now
when i call

we moved in ways
not to be understood
don't try so hard next time
nothing is secure

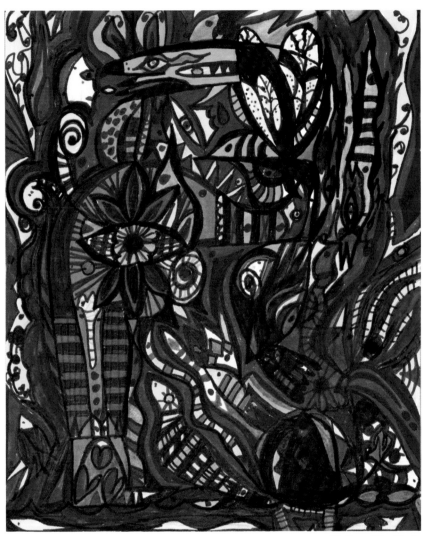

Before The Fade

Light as the Breeze

Light as the breeze some of these trees
and thee when I'm free but someday we'll
be free, won't we? I mean, someday we'll
be really free, right?

Let's hope and not hope so, beautiful child—
free of all we're taught to be beneath these
quiet growing trees.

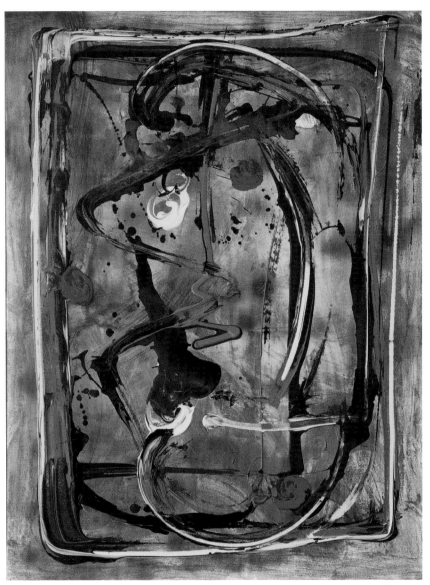

Just Like This

tiny rain

pride is not like a tiny rain
at the end of the day
and haven't we apologized
enough for the ways that
make us fall?
i guess we have a choice.
i guess we have a voice.
what once we thought was
lovely may change
and become lovelier.
pride is not like a tiny rain
at the end of the day.

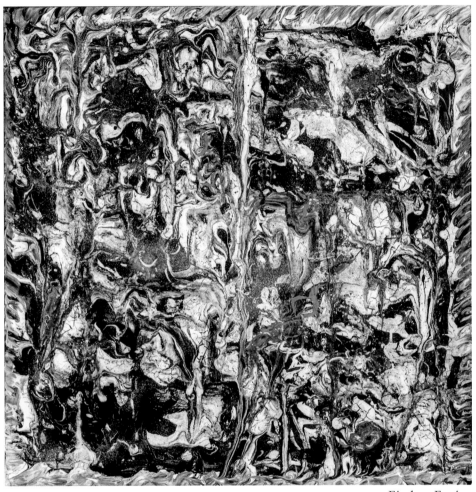

Fireless Fusion

Part Five: Last Straws

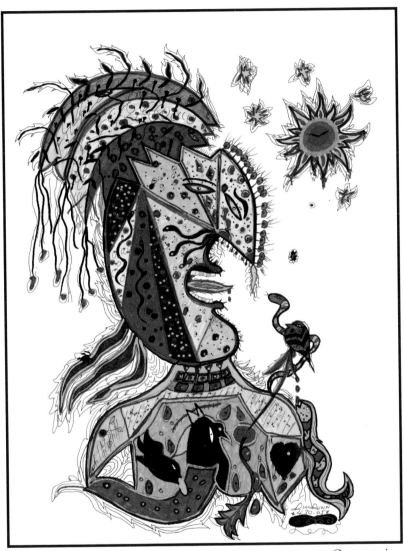

Overcoming

lechery

you can't seduce the quietness
that comes with a peaceful heart
just before dawn like the birds
just waking to sing another song

like war and peace
the clouds of today
gone tomorrow
there must be another way
subjective beauty
another mother in the cage
a mind at large
now ceasing to be
is more free than a fool
in a shakespearean play

to be or not to be
was that the question
no one is allowed an answer
not ever by a dying river
not ever now in a world gone
wrong
not ever now among
sterilized flowers

for my altar is crumbling
and my mind not wondering
who sees nature most
treacherous is closer
to your heart than the
lecherous

for what

look at me green leaf.
look at me white bird.
fill my ears with songs.
the world seems gone.
it's been gone a long
time. a long, long time.
but there is no time
the wings did flutter
to my ear.

stay there, perched and glooming
bird, the mice are far below
where the people go.
are they miserable to behold?

Unholy War

Was it you?
Was it the birds singing outside?
Was it the butterfly passing by?
Was it your lily voice?
Was it my wasted choice?
Was it the drum beat of a wounded
veteran's heart from an unholy war?
Was it the dimly lit lamp on the
broken table?
Was it the stained glass window
looking for a church?
Was it the naked couch you bled upon?
Was it the smell of the kitchen sink I almost
forgot about?
Was it the unnoticed doorway as it always is?
Was it the unpeopled garden as it often is?
Was it the magic of thought and thoughtless trees?
Was it a sign from an earthly heaven?
Was it the black longing of an orphaned child,
the stolen golden lies of another thief like thee?
Was it you, was it you, is it always me?

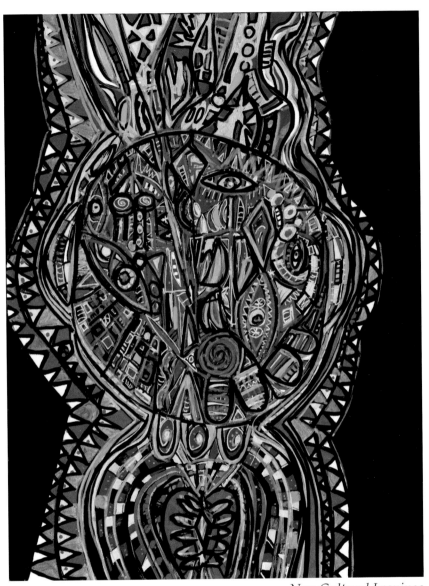

Non-Cultural Leanings

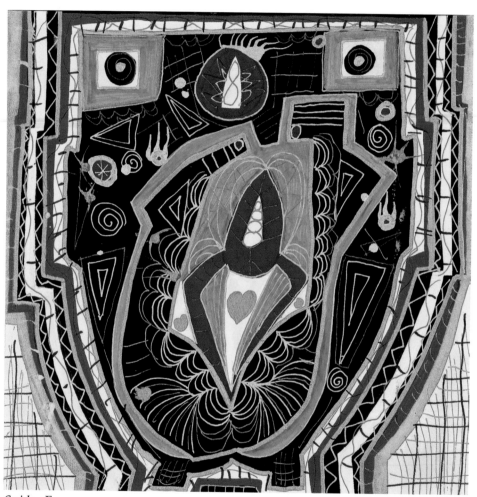

Spider Face

not hell

the branches of dawn stripped
from the tree of hope, old souls lay
fallen in the poverty of dust, death
is like lust and feeds an unknown
future—
portraits of one night's pleasure
downloaded then only deleted
by illness and death again and again—
while people save their hard-driven
smiles for awhile if lucky at best
and store them with all the rest—
out of a thousand lonely throats
moan one heart—
pluck not this flower be still
there's a child over the hill
with a magical bell
he dances still with frogs
and toads and tomorrows
not hell—
how old have we become
with market eyes shifting
selling what can't be bought
or sold but open to offers—
my trinket soul is priceless
but our pleasures seem not

Unsad Sensitivity

A grave and fine private lunch outside the window of the glass house.
The feed too was fine. Ah, death with pure cream. Nothing like it,
now, yesterday, or tomorrow . . .
The Piano plays itself for you.
The unwired yogis smile from behind the curtain.
Check my chakras and the time. But the phone is bleeding
fetid wine. And all we ever are now, is blind.

The Slanting Light

The slanting light in the afternoon forest
and the gulfs like cracked and barren
landscapes in his mind where a window
opened but it was all senseless, just utterly
senseless and ridiculous, utterly ridiculous.

Monday came and went.
The authorities said, 'no smoking, no dancing,
and no music plays here.' And it was obvious.

The sun kept shining, trees kept their presence
but I was all over the place, messy within, and
messy without.

Dreamland is flooding. Sorrow fills the sea.
The nature of the dead walks by half dead,
numb, dumb and blind.

The trees wave, the water seeps.
The maid weeps like a broom.

Twenty-three arrows shoot through a fire.
No fire lasts forever, except mine.
But the image of your dripping hand casts shadows
now up to the point of the stars' tip and babies burn
down the road, the queen has fallen.
The crest of the moon dips down into another void.
Or is there only one?

continued

The nemesis is maimed now, and named.
He is everyone and me.

Babies burn down the road. The violin men
swoon in their frozen heads, the girls get caught laughing again,
senselessly, ridiculously, hypnotically;
staring intently at the playlist, and the lowly lilies
bitterlessly flow in a pond of serene acceptance.

A Long Time

We melted before your irony.
We lived up and we broke down,
to whom now be bound?
—In quietness or sound . . .
In silences sold, in screams so cold.
A lifetime in disguise; we are alive
we proclaim, and then we die.
Tears echoing smiles.
Resounding.
Unmapped obligations
free of rewards and destinations.
To whom now be bound?
Before the light-dark,
before the dark-light.
Fodder for a distant storm.
There was I, I?
If I were I . . .

In a room full of flowers,
I'd rather look at you.

Autumn of another world.
Might as well be.
I'll remember you when the
morning glory dies by the window,
and until then I may think of little
else but you.

Obnoxious Doors

Dark angel child. That's my new story of you.
And I shall not stay away, not stay away.

Dark little shadow of a flame, aren't you still a sweet flower?
Or was that just another game?

Wild as the night was deep under a ragged tree with lipstick
and black paint all over me.

We couldn't see the stars because you were so bright.

We sang through the sorrow and we sang through the night.
We sang to the brave and we sang to the grave.

The young and the old opened our hearts.

We sang like blind men at a deaf parade.

Like night eagles of the stars now we roam.

A mind with wings and fire for every bridge to burn.

running water

free as running water
higher than the clouds
helpful as the earth
humble as a servant
beautiful as her eyes
graceful as a stem
deep as a song
quiet like a mountain top
forgiven like a saint
thankful as a beggar
contented as a lover
frailer than the flowers
stronger then steel
gentle as a feather

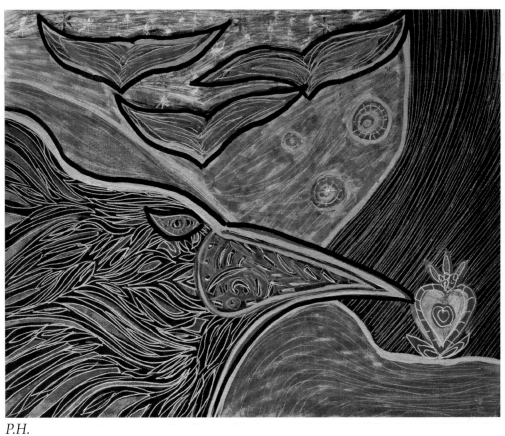

P.H.

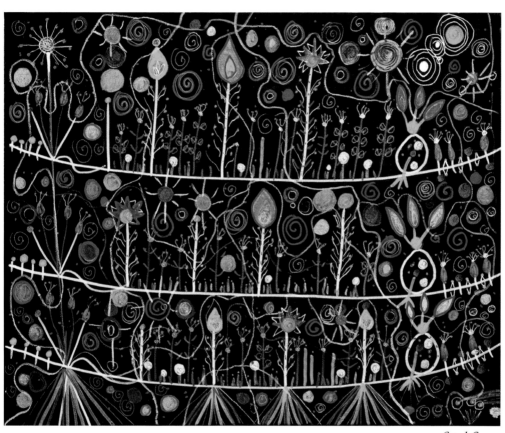

Soul Song

A Regretful Poem

The bloody yawn,
the inscrutable officers of order
and endangered justice,
a cruel game in a gone land,
like one's own desires.

Once, were you a soft blue aging man
who said to his loving wife, "it's time to go."
And didn't I agree, while silently sharing
my last piece of bread with the birds
in the gutter,
and the hypnotic trance of your words
were working upon my mind.

Ha. Ha. Ha. Have a nice day,
and our arms were all empty
on a little loving twilight full
of seeking and reeking of hopefulness.

These are not tragic mornings but it's getting
difficult to understand the only salvation
is the child, the child who must forever go on.

only another dream

we were the only ones with our mouths closed
and our eyes were opened just slightly.
you held your hand a certain way that revealed
what you may have been thinking, unconsciously.
does time and distance really keep us far apart?
is it true that if one thinks of another in solitude
or in a quiet moment, that it is only another dream?

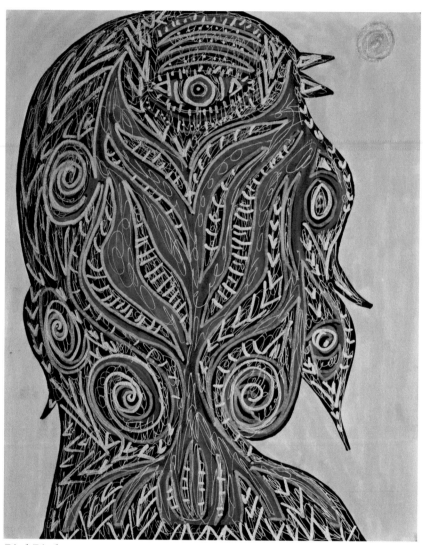

Bird Birth

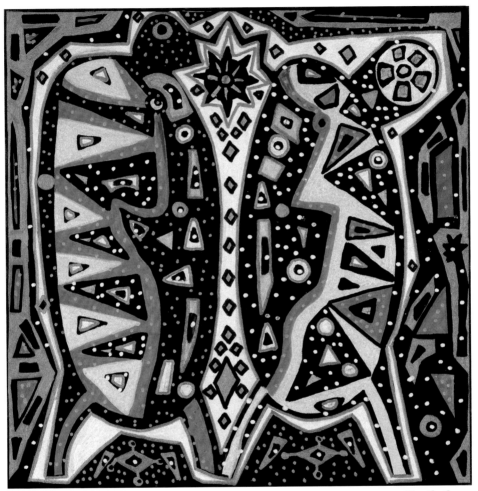

Turtle Soup

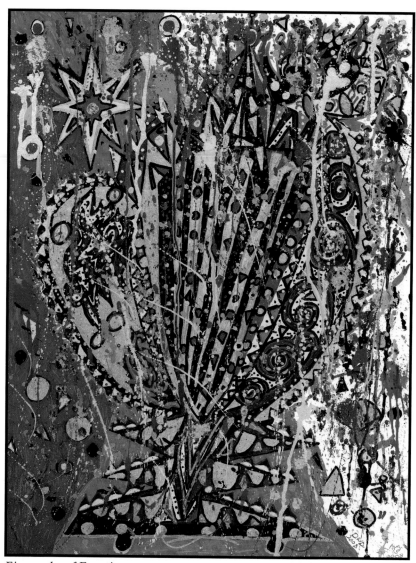

Fireworks of Emotion

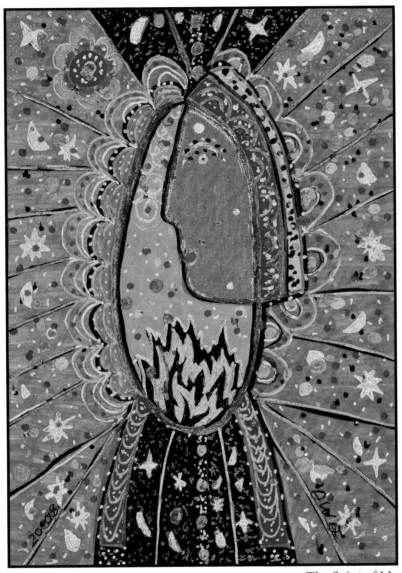

The Saint of Me

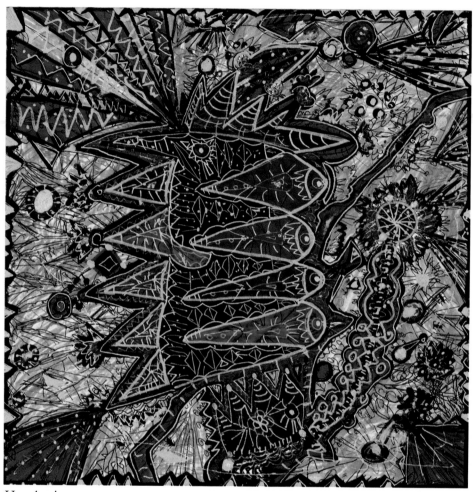

Her Again

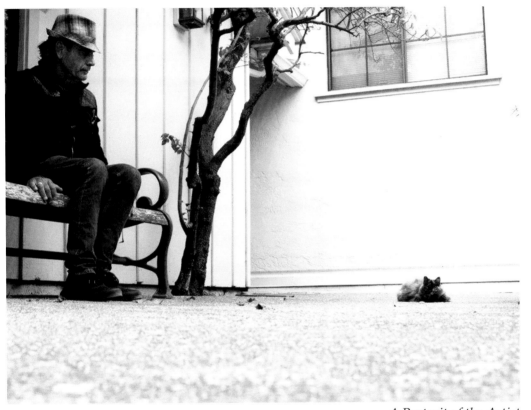

A Portrait of the Artist